TREACHEROUS TRANSPARENCIES

Thoughts and observations
triggered by a visit to the
Farnsworth House

Bruno Taut
Ivan Leonidov
Marcel Duchamp
Mies van der Rohe
Dan Graham
Gerhard Richter

Concept and Text
Jacques Herzog

Photographs of the Farnsworth House
Pierre de Meuron

ACKNOWLEDGMENTS

The trip to Chicago and the visit to the Farnsworth House took place on the occasion of the MCHAP Prize. The prize was awarded for the first time in Fall 2014 to Álvaro Siza and Herzog & de Meuron at Crown Hall of the IIT in Chicago. The following day, a group of visitors—Álvaro Siza, Wiel Arets, Kenneth Frampton, Dirk Denison, Pierre de Meuron and I, as well as a few other guests—went to the Farnsworth House. Arets and Frampton first asked Siza and then also Pierre and me to get together for a conversation in the living room of the Farnsworth House. An audio-visual recording was made of this conversation. Although we already had a few critical questions at that time, the following thoughts did not take concrete shape until later and in view of a lecture at the IIT in Spring 2016.

We are grateful to Wiel Arets, Dean of the College of Architecture at the IIT in Chicago. It is thanks to his initiative that we were invited to take this trip and, as a result, came upon unanticipated insights into the notion of "transparency."

CONTENTS

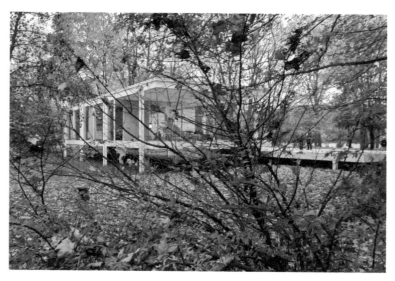

Mies van der Rohe, Farnsworth House, Plano, Illinois, 1945-1951
Autumn 2014

INTRODUCTION

In Fall 2014, Pierre de Meuron and I went to see Mies van der Rohe's legendary Farnsworth House with a small group of architects and teachers from the IIT in Chicago. These pictures and thoughts ensued after our visit.

Ludwig Mies van der Rohe's (1886-1969) truly iconic achievement, designed in 1945 and built in 1951, was revealed in all its crystalline purity on that beautiful day in October. His building was surrounded by an autumnal array of colors, which contribute to its enduring renown. The circumstances could hardly have been more auspicious for visiting a place and then, on leaving, finding oneself enriched by one of those relatively rare architectural experiences that do happen now and again, and are so wonderful because they are irresistibly overwhelming. But that is not what happened.

On the contrary: the longer Pierre and I looked at the building, studying the details of the structural joints and the proportions, and most especially, talking about its location on the property and its curiously "indecisive" height above the ground, the more we began to wonder. What was the architect's rationale? What was important to him? The natural surroundings? The people? Or simply the architecture? How do human–nature–architecture work together in this particular case? What approach did the architect take to this triangle of fundamental forces that are the essence of every architectural project?

Treacherous Transparencies analyzes transparency as expressed in architecture and art in an attempt to understand the intentions and objectives that underlie its use by pertinent architects and artists.

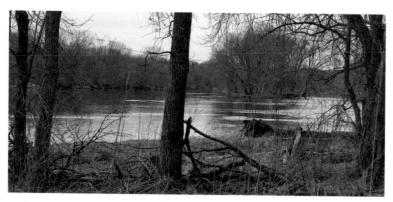

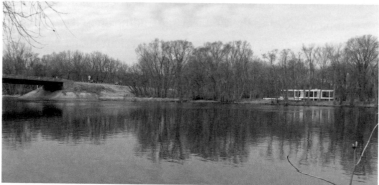

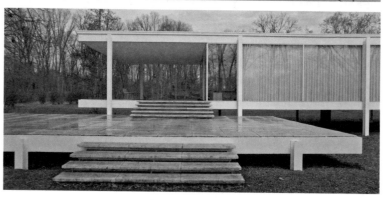

Farnsworth House
Spring 2016

INTRODUCTION

Transparency is not simply transparency. Its manifold nuances and complexions invest it with the intriguing artistic potential to express ambivalence. On the whole, however, transparency is connoted with positive associations and hopes: in politics, finances, and buildings. Transparency is viewed as an antithesis to all that is concealed; it even allays doubts because nothing remains hidden, everything is revealed. Nonetheless, such seemingly unconditional exposure is still only appearance.

Let us examine the nature of transparency by looking at a few famous examples. To generate transparency, architecture—and art—rely on physical devices, in particular glass, crystal, and mirrors.

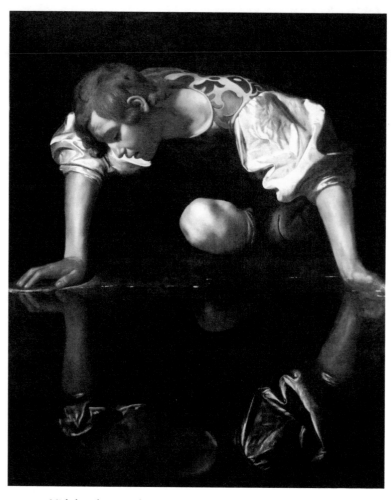

Michelangelo Merisi da Caravaggio (Caravaggio), *Narcissus*, 1597-1598
Oil on canvas, 111.3 × 95 cm
Galleria Nazionale d'Arte Antica di Palazzo Barberini, Rome

GLASS AND MIRRORS

Glass and mirrors are everywhere, in every one of the world's cities. They exist in every conceivable shade of transparency and reflection, in all shapes and colors, in offices and commercial buildings, housing and trade, industrial buildings and airports, and, of course, in seductive storefronts and shopping malls. Glass and mirrors have become ordinary, unspecific, and even mundane. They have lost the allure and the magic of old.

Glass has always had a magical appeal, ever since ancient times— until recently that is. Incredible, people thought: how is it possible to produce a material that is solid matter and yet nearly or completely invisible? How can a surface, to say nothing of a body, be at once transparent and solid without melting like ice? Why do we actually see our own face on the glass surface? In earlier times people could only look at their faces in the reflecting waters of a lake or in a puddle!

Bruno Taut
Die Stadtkrone
1919

Marcel Duchamp
Le Grand Verre
1914-1923

Ivan Leonidov
Città del Sole
1944

Ludwig Mies van der Rohe
Farnsworth House
1945-1951

Dan Graham
Alteration to a Suburban House
1978

Gerhard Richter
Acht Grau
2002

ARCHITECTURE AND ART TRACE TWO DISTINCT, INDEED CONTRADICTORY LINES OF DEVELOPMENT

In the following we will look at a few important works by selected artists and architects for whom transparency is an artistic strategy, which they implement primarily with glass and mirrors but with other media as well.

Many of them already attracted our attention and curiosity as young architects although, at the time, we were not specifically conscious of what it was that made their work so interesting.

Our spontaneous visit to the Farnsworth House—this revered icon of architectural modernism, especially among young architects—has given us concrete impetus to analyze more closely this latent and diffuse interest that has been with us for such a long time.

The architects and artists that we have brought together in this context form an unlikely alliance: Bruno Taut, Ivan Leonidov, Marcel Duchamp, Ludwig Mies van der Rohe, Dan Graham, and Gerhard Richter. But they do have something in common: their art marks salient way stations in the development of modernism up to the present day.

One might undoubtedly name other architects and other artists, who have gone down in history for their equally enduring impact in the course of these developments, but none who could question the fundamental insights advanced in this text.

ARCHITECTURE AND ART TRACE TWO DISTINCT, INDEED CONTRADICTORY LINES OF DEVELOPMENT

In art, transparency opened avenues to radical, critical, and pessimistic social discourse, while in architecture, transparency was propagated as an expression of a new and open society in harmony with nature.

Artists did not trust transparency, while until recently architects associated it with awe, hope, and veneration. Artists saw transparency as mere appearance; they used it to cast doubt upon the world and inquire into the here and now. Starting with Duchamp, artists "deconsecrated" the art world while the architects of modernism, epitomized by Mies van der Rohe, aspired to an architectural universe of the sublime, the ideal, and the affirmative, to a new and better world liberated from doubt and questions.

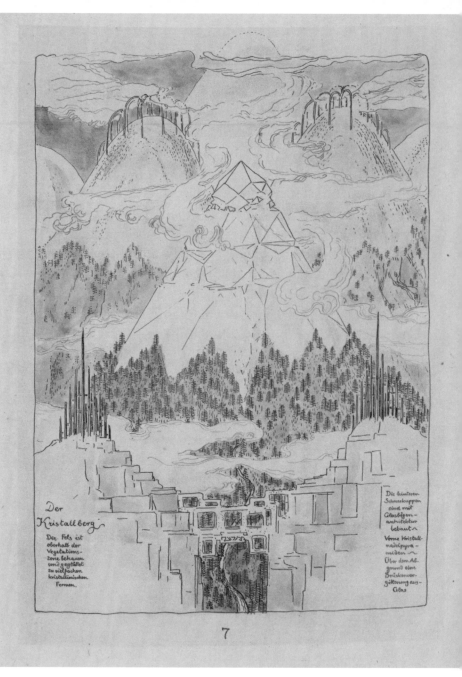

Der
Kristallberg

Der Fels ist
oberhalb der
Vegetations-
zone behauen
und gestaltet
zu vielfachen
kristallinischen
Formen.

Die hinteren
Schneekuppen
sind mit
Glasbögen-
architektur
bebaut.

Vorne Kristall-
nadelpyra-
miden.
Über dem Ab-
grund eine
Brückenver-
gitterung aus-
Glas

7

Bruno Taut, Der Kristallberg (The Crystal Mountain), 1919
Pen, gray ink and pencil on paper, 49.6 × 50 cm
Akademie der Künste (Academy of Arts), Berlin, Archive Bruno Taut

BRUNO TAUT

DIE STADTKRONE

Both Bruno Taut (1880-1938) and Ivan Leonidov were among the foremost pioneers of architectural modernism. For them transparency was not a crucial factor, neither in design nor in subject matter. Other concerns had priority. In the 1920s, Taut designed his extraordinary residential housing estates, investing their architecture with a social dimension that few of his modern contemporaries achieved, while, during that same decade, Leonidov boldly aspired to innovation, to a revolutionary new beginning.

Although their contribution to modern architecture could not be more disparate, they both cultivated an intense, long-term interest in an architectural idiom for the sake of a "higher authority": in Taut's case, an explicitly religious, divine authority; in Leonidov's case, a hierarchical, vertical order that features in numerous designs until well into the 1950s.

Bruno Taut's book *Die Stadtkrone* (*The City Crown*, 1919) is a goldmine for our theme of investigating transparency as a leitmotif of modernism. His philosophically elucidated utopian design of the ideal city is described in meticulous detail and culminates in a glass crown, in "pure architecture" with no functional constraints. It is the

> *... highest building that reigns above the whole as pure architecture, entirely void of purpose. It is a crystal house made of glass, a building material that is matter and yet more than ordinary matter because of its shimmering, transparent, reflecting essence.*

(Taut 1919, p. 67)

Bruno Taut, Ansicht nach Westen (View towards the West), 1917
Published in Bruno Taut, *Die Stadtkrone*, Jena: Diederichs, 1919

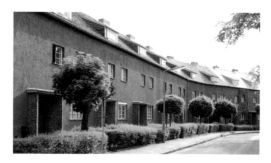

Bruno Taut, Hufeisensiedlung (Horseshoe Estate), Berlin, 1925-1933
Photograph showing one row of houses, 2011

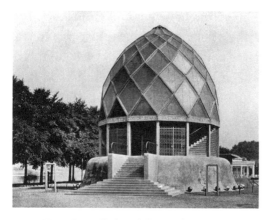

Bruno Taut, Glashaus (Glass Pavilion), 1914
Deutscher Werkbund Exhibition, Cologne, 1914

BRUNO TAUT, DIE STADTKRONE

Taut calls for a renewal of architecture's "beautiful bond of sculpture and painting"; he sees his utopia as a *Gesamtkunstwerk*.

> *Cosmic transcendental thoughts mirror the colors of the painter, "world regions," and a new wealth of sculptural form embellishes all the architectural elements, settings, connections, supports, brackets, and so on.*

(Taut 1919, p. 68)

Elsewhere, Taut rhapsodizes about the blissful effect of his glass crown—so much so that we could almost read it as a prescient hymn to the Farnsworth House.

> *Bathed in the light of the sun, this crystal house reigns above everything like a sparkling diamond, glittering in the sun as a sign ... of the purest peace of mind. In its space, the lonely wanderer discovers the pure bliss of architecture.*

(Taut 1919, p. 68)

Taut's descriptions of his utopian architecture consistently embrace nature, being in nature, and being one with nature, mountains and the world of crystals. These thoughts are deeply colored by theosophy and informed with a profound, mystical admiration of Meister Eckhart. The intense wish to link the visible—such as the crystalline world of the mountains as a metaphor for his architecture—with invisible but extremely effective energies recalls the ideas advanced by Joseph Beuys. Taut's drawings of *The City Crown*, delicately delineated and interwoven with texts and comments, also reveal a kinship with his later compatriot.

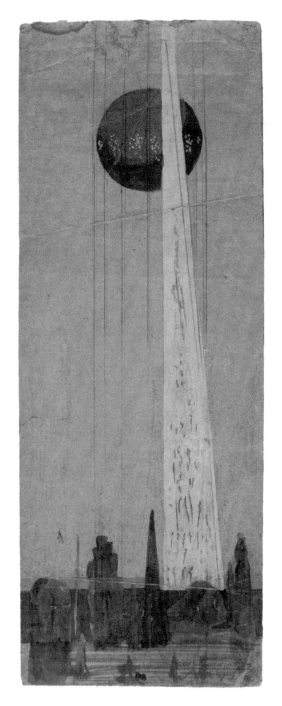

Ivan Leonidov, Città del Sole, view with tower and sphere, ca. 1944

IVAN LEONIDOV
CITTÀ DEL SOLE

Ivan Leonidov (1902-1959) did not explicitly address the transparency of glass or crystal and mirrors. But he did speak about transparency and transcendence to illustrate his architectural visions. His work is diverse, multilayered, and stylistically unbiased. He had a penchant for purely geometric bodies and was fascinated by technique and movement. However, these interests, the point of departure for a new architectural idiom, were thwarted because of political change and a revisionist climate.

Leonidov's early work is brilliant and innovative—full of explosive energy forged by the "talent factory" Vkhutemas, the Soviet equivalent of the Bauhaus. But his late work was no less interesting, in particular the introduction of decorative elements, which he had spurned in the twenties. On the other hand, his lifelong fascination with platonic or pure bodies, especially circle and sphere, never waned. These pure spherical bodies are of central, iconic importance in his most famous design, the Lenin Institute (1927), and also in his ideal city, Città del Sole (City of the Sun, 1943-1958), inspired by Italian philosopher Tommaso Campanella's book of the same name.

As pure forms, they were "innocent" for they had not been abused by any religious or political powers and were capable, in revolutionary times, of embodying the nascent beginnings of a new society. A few years earlier, Malevich had followed a similar trajectory in his Suprematist work, in such paintings as *Black Square* and *Black Circle*: he had created a new form of ultimate icon.

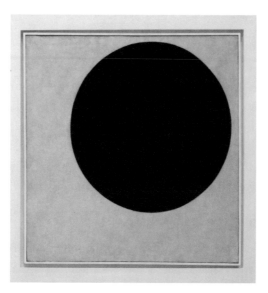

Kazimir Malevich, *Plane in Rotation*, known as *Black Circle*, 1915
Oil on canvas, 79 × 79 cm, private collection

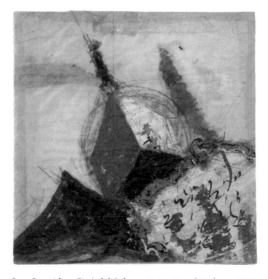

Ivan Leonidov, Città del Sole, variation in cubic shape, 1948

IVAN LEONIDOV, CITTÀ DEL SOLE

Leonidov's City of the Sun and Taut's *The City Crown* show affinities: the ideal of a freer society is based on a social utopia and takes shape in a hierarchically structured architectural idiom of pure, platonic forms.

In addition to platonic bodies, Leonidov also explored gravity as a weighty historical vehicle that he attempted to overcome. In his design for the Lenin Institute, cables and guy wires run in all directions linking the various volumes and anchoring them in the ground. In this way, he created a whole that generates a sense of lightness and transparency.

The empty and open space in between these cables describes an astonishing, transparent volume, one that was new to architecture at the time. It was an expression of hope, of floating instead of weight, and stood in contrast to the foregone history of architecture. It was the beginning of a new axiom of modernism, propagating the horizontal, floating body and incorporating it into its canon.

This modern obsession characterizes the Farnsworth House and earlier designs by numerous architects as well as projects into the present day.

As indicated above, Taut longed to create architecture in which painting, sculpture, and structure are reintegrated into a single whole. Leonidov had also been exposed to these ideas early in his career at the Vkhutemas. Traditional distinctions between the arts would no longer prevail, similar to the aspirations of the Bauhaus. In the early years after the revolution, the aim

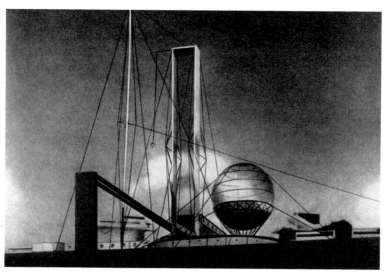

Ivan Leonidov, proposal for the Lenin Institute, Moscow, 1927

IVAN LEONIDOV, CITTÀ DEL SOLE

was to integrate art into the productive everyday life of the people, but an age-old longing resonates in the idea as well: the desire to resurrect the spirit of the medieval workshops of Renaissance artists.

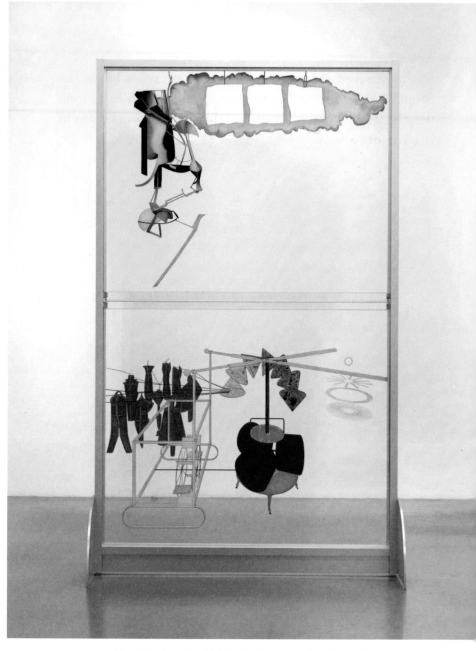

Marcel Duchamp, *La Mariée mise à nu par ses célibataires, même*
(*The Bride Stripped Bare by Her Bachelors, Even*) or *Le Grand Verre (The Large Glass)*
1915-1923, reconstruction by Richard Hamilton in 1965-1966
Oil, lead, dust, and varnish on glass, 277.5 × 176.9 cm, Tate, London

MARCEL DUCHAMP
LE GRAND VERRE

What an incredible contrast to the territory charted by Marcel Duchamp (1887-1968). This freethinking pioneer had already abandoned painting around 1912 to embark on a journey that would completely revolutionize the meaning of art.

Like Leonidov, Duchamp and other artists were also fascinated by the potential of technical and industrial advances at the start of the twentieth century. In fact, artists were captivated by these advances long before they penetrated the minds of architects and even before the First World War, which led to a radically new awareness of what art could be and achieve in the twentieth century: the perfect beauty and innovative potential of machines and propellers inspired a visual idiom that might be described as "imitative analogy." Take, for example, the paintings of Fernand Léger or Robert and Sonia Delaunay as well as numerous constructivists, and in architecture— albeit 10 years later—Leonidov, of course, and Le Corbusier.

Duchamp's achievement lay in refusing to restrict himself to analogy and form. He saw the mechanical universe as penetrating human beings and dominating them. It was an implacable, despotic universe and certainly not heroic; much less did it herald a hopeful future. As demonstrated by his *Bachelor Machine*, Duchamp exploited the mechanical to reveal something that is ordinarily invisible, that lies within, that is psychological, unlike other artists, who merely depicted and took possession of what was visible to begin with, namely, the astonishing miracle of technology.

Duchamp started working on *Le Grand Verre (The Large Glass)* in 1914 and stopped in 1923, at which point he declared it to be

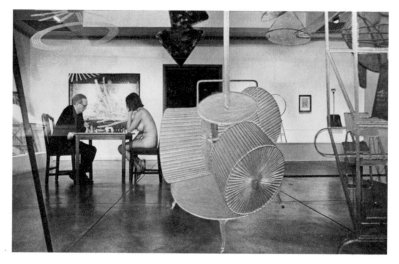

Marcel Duchamp and Eve Babitz playing chess
Pasadena Art Museum, California, 1963. View through *The Large Glass*

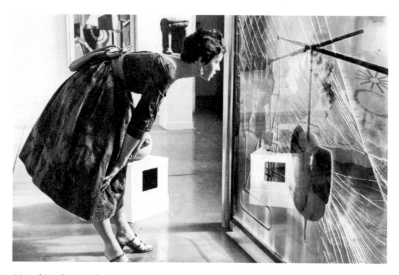

Marcel Duchamp, *The Large Glass*, 1915-1923, restoration by Marcel Duchamp, early 1930s
Oil, varnish, lead foil, lead wire, and dust on two glass panels, 272.5 × 175.8 cm,
Philadelphia Museum of Art, Bequest of Katherine S. Dreier, 1952

MARCHEL DUCHAMP, LE GRAND VERRE

"unfinished." *The Large Glass* contains so much and leaves so much unsaid—for which reason it has probably been subjected to such meticulous and unprecedented study. But it still astonishes. It is still enigmatic and cryptic. What is it? Is it a sculpture? A painting?

Technically speaking, it is painting on and between two vertical panes of glass. It has no background; we can see through it, indeed we have to see through it, for we have no choice. This means we always see the room behind it, the people behind it, and depending on the lighting, ourselves, the viewers, mirrored in the glass.

And what are we viewing? The bride stripped bare? The bachelors or the famous chocolate grinder that fuels the bachelors' desire? And why does Duchamp call *The Large Glass* an "unfinished work"? Were still more questions and still more conundrums meant to be part of this object? Were doubts and unanswerable questions to be insinuated into his art and extended to viewers and their life realities?

Duchamp did invite chance or fate to become part of the work. When *The Large Glass* broke in transport, he repaired it only by fixing the fragments. The splintered pane of glass became part of his work of art, an attribute like a human scar.

The Large Glass contains much that garnered the admiration of Duchamp's contemporaries and possibly also provoked envy. It expanded the notion of art, but quite obviously did not extend as far as the world of architects.

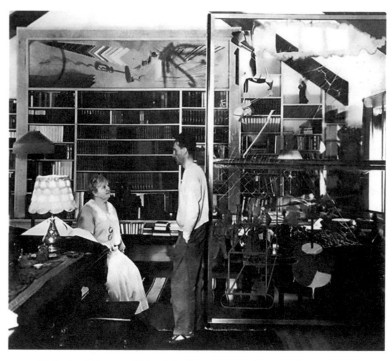

Katherine S. Dreier and Marcel Duchamp, next to *The Large Glass* (restored)
in Dreier's library, West Redding, Connecticut, August 30, 1936

MARCHEL DUCHAMP, LE GRAND VERRE

Was this new concept of art too alien, too intellectual, too "dirty" or informal? Was the psychological and also the erotic aspect too challenging, something that did not fit in with the modernist credo and the various "rappels à Messieurs les architectes"? Why were the great architects of modernism incapable of recognizing the potential of these psychological aspects for a more humane and at the same time more radical architecture?

A commission like the Farnsworth House could not have been more ideal for aspiring to go beyond the purity of construction. The dissatisfaction and discomfort of the client—in addition to the well-known personal issues—are also related to Mies van der Rohe's unwillingness and inability to recognize the psychological aspect of architecture and incorporate it into his planning.

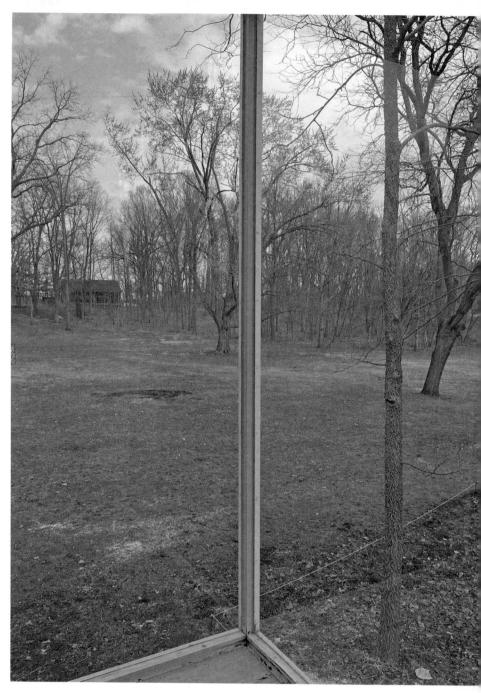

Mies van der Rohe, Farnsworth House, Plano, Illinois, 1945-1951
Spring 2016

LUDWIG MIES VAN DER ROHE
FARNSWORTH HOUSE

The landscape around the Farnsworth House was, of course, wilder, more romantic, and more isolated in the late 1940s, with a river nearby that caused periodic flooding. Today, there is a bridge across the river close to the house and the subsequent owner, Lord Palumbo, put up several buildings to make the location more livable. Even so, it is still a remote and lonely place surrounded by woods.

A weekend house for a single person, a woman, a physician from Chicago: what kind of house should that be? A few spontaneous thoughts on a hypothetical possibility follow:

A house as a haven that protects users from the outside world and offers a private sphere inside. The house would therefore have to be subdivided or, at least, provide a small place to retreat somewhere inside. The unobstructed view from the inside out would have to be combined with a maximum of visibility protection from outside in. The house would be one with nature, would respond specifically to the climate, light, and weather of the location. It would blend into its surroundings, like a camouflaged object. This would lend it a kind of modesty that would not betray the authors/architects and the time in which was built, or at least not instantly. Could it perhaps even be built from on-site materials? It should be a comfortable house and *gemuetlich*, with a certain nonchalance that is a casual invitation to stay for a while, with a space that can be flexibly furnished and used, where the arrangement and choice of furniture is not scripted, a room capable of responding to specific needs.

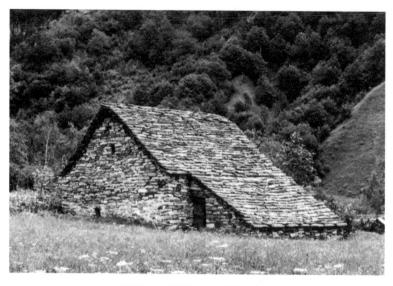

Shieling in Val Verzasca, Switzerland

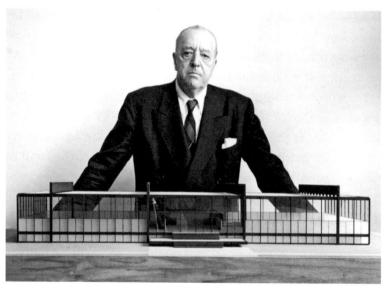

Mies van der Rohe with a model of IIT S. R. Crown Hall, Chicago

LUDWIG MIES VAN DER ROHE, FARNSWORTH HOUSE

A house of the kind that has always been built, through the ages, a house that is traditional and therefore universal.

Did Mies think about these things, too? Maybe: because he was a firm advocate of timelessness, respect, and modesty. But even so: Mies van der Rohe wanted none of that. He couldn't.

A traditionalist known and much admired by his fellow architects for his careful and modest approach to materials and structural detailing, he had here abandoned the venerable and time-tested path of architectural tradition and structural knowledge. He was unable to draw from the wellspring of tradition because he no longer saw any potential in it for the new, universal architectural idiom that he was looking for, along with other great architects of his time.

His plans and buildings show that the intensity and radicalism of his quest increased after he moved from Germany to the United States. And, indeed, he thought that he was about to find what he was looking for to implement this new universal language of architecture. He was driven by an idea and by the will to translate that idea into reality: Farnsworth House — a project of that kind cannot be the outcome of a planning process and exchange with a client. It is much more the expression of a will and a conviction that something great must be created and that this was the moment to do so: pure architecture, essentials, nothing superfluous, no traces of authorship, timelessness, eternity, beauty!

Did he achieve that?

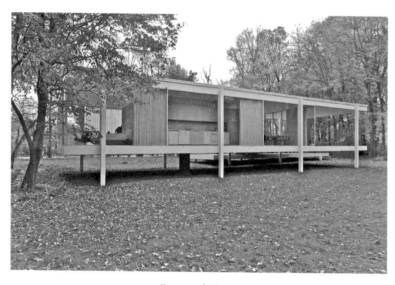

Farnsworth House
Autumn 2014

LUDWIG MIES VAN DER ROHE, FARNSWORTH HOUSE

He did create beauty, incredible, lofty beauty. That was the first impression we had, Pierre and I, when we approached the house and caught a glimpse of the white steel skeleton through the autumn leaves of the park.

The supports, though incorporated into the horizontal and vertical composition, are clearly identifiable as independent features, as if they could be removed and carried away like spolia from buildings of antiquity. Are they ordinary industrial steel supports or are they crafted replicas that merely imitate industrial aesthetics? Ultimately this question, originally posed perhaps in criticism of Mies, is irrelevant. He needed the immediacy of this "essential" industrial shape to make the other shapes, surfaces, and materials appear essential, for instance, the travertine floors and the wood clad core. Mies himself often belabored the term "essential" as the ultimate goal of his architecture:

Only questions into the essence of things are meaningful.

(Mies van der Rohe 1961, in: Neumeyer 1991, p. 30)

But did Mies manage to achieve his obsessively pursued goal? A travertine floor or wood cladding cannot be "essential," least of all in the Farnsworth House. Their standardized detailing can hardly be distinguished from other surfaces of the same materials in the house. They are, after all, just surfaces: a surface covered with travertine, but not a "floor" that supports and holds you down, that grounds you in a way that we have all experienced, especially in traditional, solidly built houses with stone or wide plank floors.

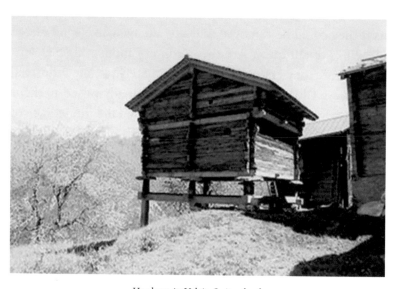

Hay barn in Valais, Switzerland

LUDWIG MIES VAN DER ROHE, FARNSWORTH HOUSE

Mies clearly appreciated traditional and "primitive" architecture, in which every single element is a perfect and self-evident part of the whole with no superfluous leftovers — an architecture which, as he put it in his inaugural address of 1938 at the IIT in Chicago, leads us out of "the irresponsibility of opinion" and into "the responsibility of insight." On that occasion, he expressed his respect for traditional craftsmanship and architecture almost lovingly and with great eloquence, for he spoke of

> *... meaning in every stroke of an axe, expression in every bite of a chisel.*
>
> *... What feeling for material and what power of expression there is in these buildings! What warmth and beauty they have! They seem to be echoes of old songs. And buildings of stone as well: What natural feeling they express! What a clear understanding of the material! How surely it is joined! What sense they had of where stone could and could not be used! Where do we find such wealth of structure? Where more natural and healthy beauty? How easily they laid beamed ceilings on those old stone walls and with what sensitive feeling they cut doorways through them!*
>
> (Mies van der Rohe 1938, in: Johnson 1978, p. 198)

Who would have been better suited to creating architecture that transcends questions of style and time, buildings that are truly made for their users and for a modern industrialized world than this trained stonemason, skilled in handcrafting his materials? Mies was convinced that he was doing just that and, accordingly, described his personal architectural development as the "disciplined path from material through purposes of building" to "the sphere of pure art." (Neumeyer 1986, p. 34)

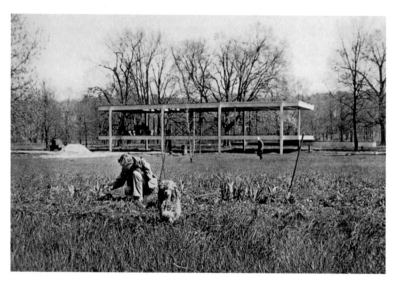

Farnsworth House under construction, Edith Farnsworth in the foreground

LUDWIG MIES VAN DER ROHE, FARNSWORTH HOUSE

However, primitive peoples and traditional master craftsman have never been driven by the desire to create "pure art." Pure art is an invention of modernity, an ultimate milestone to which Malevich aspired, and later Ad Reinhardt in his radical demand that painting be "art as art." Was it even possible for purpose to transform architecture into "pure art," as Mies repeatedly claimed?

The essence of Baukunst is rooted totally in the purposeful. But it reaches across all levels of value, to the realm of spiritual being, into the realm of reason, the sphere of pure art.

(Mies van der Rohe 1938, in: Neumeyer 1986, p. 34)

Mies's statements on architecture are not coherent, but they do undoubtedly reinforce the ambivalence that we sensed when we visited the Farnsworth House. Mies cultivated painstaking attention to details, which he reduced to their minimal "essential" form. Knowing that this reductionist approach could not suffice to create the "essential architecture" to which he aspired, he resorted to other strategies as well. He worked with opposites and juxtapositions, like the above-mentioned industrial steel outside the pavilion and noble, vulnerable materials inside. The contrast was meant to heighten the effect of the materials, to make them even "steelier," "woodier," and "stonier." But that does not miraculously make them "essential."

This is particularly evident on comparing Mies's flooring with the wooden floor in a traditional house. Or on comparing the elevated Farnsworth House with the wooden houses in Switzerland's mountainous Canton Valais, which are also raised above the ground and perch on cantilevered stone slabs. As in Mies's pavilion, it is a functional necessity to raise these build-

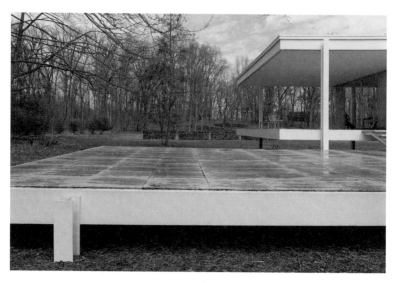

Farnsworth House
Spring 2016

LUDWIG MIES VAN DER ROHE, FARNSWORTH HOUSE

ings above the ground. But they are not just boxes that have been lifted off the ground: paradoxically the weightiness of the stone slabs sets these traditional Valaisan houses afloat. The slabs are an indispensable constituent of the building and yet they are still independent, weighty elements of their own. They are simply raised slabs of stone. Are these stone slabs "essential"?

In any case, this is architecture that cannot be invented; it is of the same beauty that inspired Mies's love of traditional architecture.

But how did he deal with it, what lessons did he learn from it? It cannot have been the origin of his persistent reduction. Valaisan stone slabs, for instance, did not evolve through a reductive process of design. They are simply slabs of stone, sometimes a bit bigger, sometimes a bit smaller. That was obviously not interesting enough for Mies. It probably suited neither the way he thought nor the way he worked. He preferred the above-mentioned strategy of juxtaposing materials — or the opposition of "full" and "empty." The white steel skeleton of the Farnsworth House is a sculpturally dominant element. It encases a glazed interior that looks entirely transparent, in stark contrast to the white of the painted steel construction — as if there were no glass membrane at all.

The transparency Mies has achieved recalls Leonidov's design of the Lenin Institute. By contrasting so strongly with the steel frame, the glass windows cannot really be perceived as independent elements from inside or from outside. The thin frames,

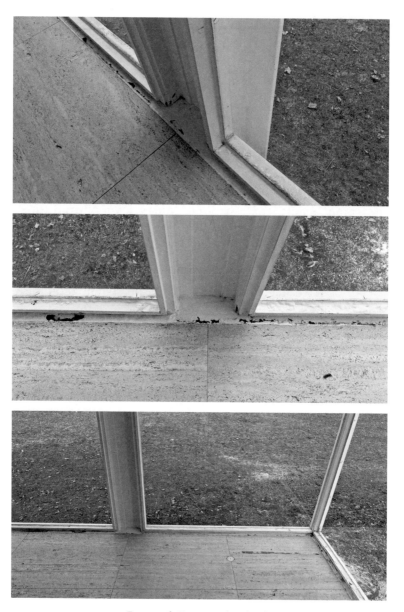

Farnsworth House, window details

LUDWIG MIES VAN DER ROHE, FARNSWORTH HOUSE

also white steel profiles, seem to be part of the steel construction. The main purpose is to create transparency.

In consequence, the glass is not treated as a material. The corresponding window details confirm that the materiality of the glass is intentionally suppressed. The steel profiles dominate; the panes of glass have merely been inserted as a filling. Technically, the glass separates inside and outside; it has no function of its own. It doesn't count and it has no identity; it would probably be better not to have any glass at all.

The most striking pair of opposites at the Farnsworth House is that of architecture and nature. For Mies, this theme was crucial to the Farnsworth project; he did not see the pair as opposites but, on the contrary, as "a higher unity" that also embraces people:

> *Nature too shall live its own life. We must beware not to disrupt it with the color of our houses and interior fittings. Yet we should attempt to bring nature, houses, and human beings together into a higher unity. If you view nature through the glass walls of the Farnsworth House, it gains a more profound significance than if viewed from outside. That way more is said about nature — it becomes part of a larger whole.*

> (Mies van der Rohe 1958, in: Norberg-Schulz 1958, reprinted Neumeyer 1991, p. 339)

Did Mies really believe what he was saying? The statement above is too naïve and even presumptuous. Elsewhere Mies — whose quiet, unassuming demeanor made such an impression on his contemporaries — reinforces this thought:

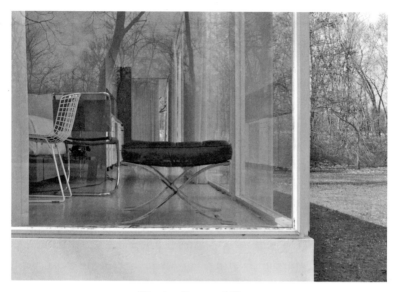

View into Farnsworth House

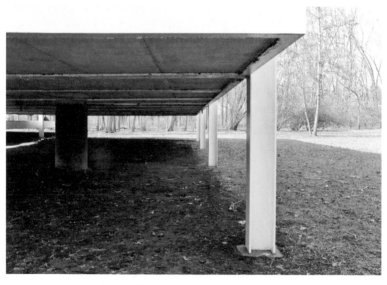

View under Farnsworth House, ground level

LUDWIG MIES VAN DER ROHE, FARNSWORTH HOUSE

I hope to make my buildings neutral frames in which man and artworks can carry on their own lives. To do that one needs a respectful attitude towards things.

(Mies van der Rohe 1958, in: Norberg-Schulz 1958, reprinted Neumeyer 1991, p. 339)

To ensure that people can "carry on their own lives" entails an independent, equal, and appropriate coexistence within the force field of people–nature–architecture.

The famous Neue Nationalgalerie (1968) in Berlin illustrates how problematic it was for Mies to keep his promise in the case of art. The vast upper story is no doubt impressive but it cannot do justice to the small format, wall-oriented art that still prevailed when it was built — at least not in the sense of enabling it to "carry on" its own life, because, assuming art does have a life of its own, it should presumably be displayed to the best possible advantage for viewers to appreciate its perceptual potential. Hanging pictures as if on clotheslines does not do the trick.

Nature should be able to live its "own life" as well; but it does that anyway, no matter how much we try to interfere.

Mies must have meant something else, but what exactly? He placed the Farnsworth House deliberately and precisely near a large maple tree. The house does not react to the tree, and the tree blithely goes on living, just as it did before the house was built. Because it is a glass house, the tree and its outdoor environs resemble a sculpture or a panoramic landscape installation, an effect that is often enthusiastically applauded:

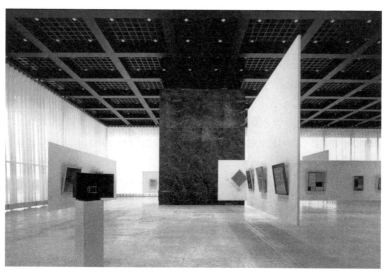

Piet Mondrian, inaugural exhibition in the Neue Nationalgalerie, Berlin, 1968

LUDWIG MIES VAN DER ROHE, FARNSWORTH HOUSE

The die for the romance was cast from the moment Mies van der Rohe decided to site the house next to the great black sugar maple — one of the most venerable in Kendall County — that stands immediately to the south and within a few yards of the bank of the Fox River. The rhythms created by the juxtaposition of the natural elements and the man-made object can be seen at a glance — tree bending over house in a gesture of caress, a never-ending love affair — and felt — when the leaves of the tree brush the panes of glass on the southern elevation. ... life inside the house is very much in balance with nature, and living an extension with nature. A change in the season or an alteration of the landscape creates a marked change in the mood inside the house. With an electric storm of Wagnerian proportions illuminating the night sky and shaking the foundations of the house to their very core, it is possible to sit in the thunderstorm and remain quite dry! When, with the melting of the snows in spring, the Fox River becomes a roaring torrent that bursts its banks, the house assumes the character of a house-boat, the water level sometimes rising perilously close to the front door.

(Palumbo, in: Blaser 1999, p. 14)

Seen in this light, the Farnsworth House becomes an instrument of perception that enhances the visual stimuli of nature and carries them into the house. However, it obviously enhances the natural climate and carries it into the house as well, as noted elsewhere:

It was perfectly predictable that a badly-ventilated glass box, without sun-shading except for some nearby trees,

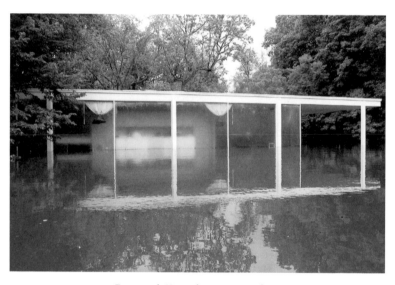

Farnsworth House during a severe flood

LUDWIG MIES VAN DER ROHE, FARNSWORTH HOUSE

would become oven-like in the hot Illinois summers, and that single-thickness glass in steel frames, devoid of precautionary measures such as convection heaters to sweep the glass with a warm air current, would stream with condensation in an Illinois winter. Mies's disregard of such elementary truths illustrates his greatest weakness as an architect — namely an obsession with perfect form so single-minded that awkward problems were loftily disregarded.

(Vandenberg 2003, p. 23)

Nature positively permeates the glass pavilion and yet it is little more than a gigantic bouquet of plants that has been draped around a precious stone for the sole purpose of making the latter even more radiant. Mies was interested in nature as decoration. He treated it as a decorative, optical, and sculptural counterpoint to his architecture. The architecture does not adjust to its natural environment and the environment is still what it always was. It is not transformed and utilized like a peasant garden, nor is it enlisted to shore up the architecture and the people who use it by, for instance, placing parts of the building toward or away from the sun, the rain, or the wind.

This purely decorative approach can also be observed in other projects by Mies. It is particularly apparent in the Barcelona Pavilion (1929): there, the angular thrust of the horizontal and vertical stone slabs is additionally accentuated through stark contrast with the nude body of a woman. In this case, "nature" is not embodied by plants but rather by the organic shape of Georg Kolbe's woman in bronze, *Alba (Morning)*. Again, the

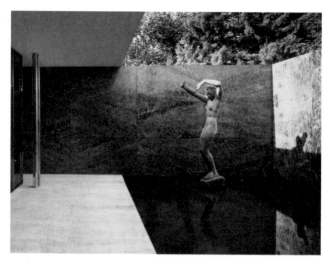

Bronze sculpture placed by Mies van der Rohe in the
Barcelona Pavilion
(German Pavilion, International Exhibition, Barcelona, 1929)

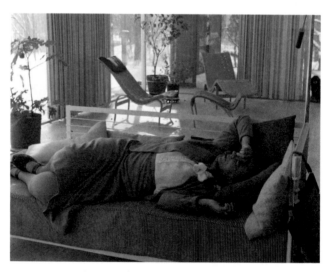

View inside Farnsworth House with unidentified woman
in the foreground

LUDWIG MIES VAN DER ROHE, FARNSWORTH HOUSE

visual effect generated by juxtaposing nature (human) and architecture is designed to benefit the latter. The placement of the naked woman in this corner of the pavilion, her arms uplifted in a helpless gesture of self-protection, is not accidental, nor is the intention cynical; it is meant to enlighten and illustrate what Mies meant in speaking of a "higher unity." The aim was to optimize the impact of his architecture: an architecture of the sublime whose true nature lay beyond nature itself and humankind.

Mies may not have seen things this way but he acted as if he did. He looked at his sketches, his plans, his models, but he saw only what he wanted to see, what he already knew, what he wanted to confirm or at most refine through an even more meticulous attention to detail. He was not seeking greater insight — at least not into the inner life of the people who had to breathe life into his architecture.

Living in Mies's house was obviously trying, if not unbearable for Edith Farnsworth, although she owned and used it regularly for twenty years, until 1971. The relationship between the architect and the client was estranged, to put it mildly, but that alone does not explain her devastating assessment:

Do I feel implacable calm? ... The truth is that in this house with its four walls of glass I feel like a prowling animal, always on the alert. I am always restless. Even in the evening. I feel like a sentinel on guard day and night. I can rarely stretch out and relax. ... What else? I don't keep a garbage can under my sink. Do you know why? Because you can see the whole "kitchen" from the road on the way in here and the can would spoil the appearance of the whole

Edith B. Farnsworth

Artifact

The dawn was close this morning when I woke
To hear some flying creature strike the pane
Of glass beside my bed--strike and flutter
For a moment, strike and beat
Bewildered wings upon the glass.

There was no light.
It was not day, or night.
I could not see the wounded flying thing
But I could hear the fluttering, breaking wing
Beating its moment out upon my pane
Of glass. Why does it not recoil, or die?
Why does it try
The sold smooth artifact to pass,
Why does it beat upon the glass?

The unseen wings are slipping down the pane;
The splintered feathers agonize in vain.
The moments pass
And in the grass
Below, there lies
My hope, and dies.

1960

Edith Farnsworth, *Artifact*, unpublished poem, 1960

LUDWIG MIES VAN DER ROHE, FARNSWORTH HOUSE

house. So I hide it in the closet farther down from the sink.
(Farnsworth, in: Farnsworth/Barry 1953, p. 270)

Not only did Farnsworth feel like a restless, prowling animal; in an unpublished poem she describes the impact of the world outside: not the visual beauty of the scenery but the sound of an unseen "flying creature" colliding with her glass walls.

The oppressive feeling of being caged and on display or of being like a guard in a lookout, surveying the surroundings, is intensified by the fact that the house is raised 5'3" off the ground. In addition to the glass transparency of the pavilion, with all the attendant questions of privacy or the lack thereof, we found ourselves more and more involved in trying to understand the curious effect of being raised off the ground.

The house was meant to float above the ground — an important axiom of modernism since the days of the Vkhutemas and the Bauhaus, when young architects were fascinated by all manner of flying objects: they wanted to defy gravity, to achieve lightness instead of weight. Mies's pavilion expresses this lightness. But the elegance of "floating" is coupled with an extremely inelegant and uncontrolled space under the house, which Mies obviously overlooked.

The space is neither high — you can't stand upright underneath — nor low, like the clapboard houses in American suburbs, where there is room at most for mice and rats. No, here the height is purely functional: it was meant to protect the house from the Fox River spring floods. We know that the height was

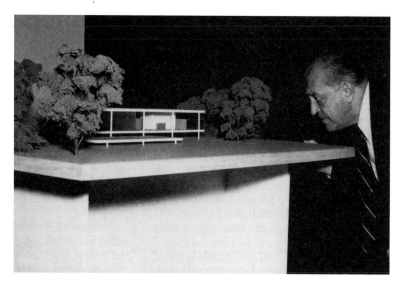

Mies van der Rohe inspects a model of Farnsworth House at a retrospective of his work
(Museum of Modern Art, New York, September 17 - November 23, 1947)

Michelangelo Antonioni, *Blow-Up*, 1966, filmstill

LUDWIG MIES VAN DER ROHE, FARNSWORTH HOUSE

miscalculated and that the house has been flooded several times. This is an unfortunate technical and functional error.

But what interests us still more is the disregard of human scale; Mies was utterly blind to the disproportionate distance between house and ground. The floor of the building reaches to your chin or neck; you can enter the space only by bending down and crawling in. There is room enough to hide or even make arrangements to sleep under the house. It is, of course, naked earth because nothing can grow there but you could feel sheltered and safe, perhaps even safer than in the glass pavilion. In any case, discovery would be most unlikely.

Nowadays visitors can peer into the space because the grass is cut short, but originally it was shut off from view by tall prairie grass, as specified by Mies. Prairie grass like pubic hair! Was his non-height such an embarrassment? Actually, the prairie grass was probably another decorative landscape item to underscore the purity of his architecture. On the old photographs showing the original state of the house with high grass all around the building, the semi-concealed non-space under the house is even more curious, even uncannier than it is today.

The old documents remind me of Michelangelo Antonioni's film *Blow-Up* (1966), in which photographs of an idyllic park suddenly lead to suspicions of murder. In one way or another, we all carry within us such images of fear and doubt.

Mies showed no interest in such concerns or simply didn't notice them. He wanted purity, neutrality, and abstraction; he

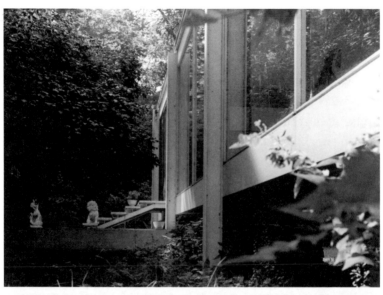

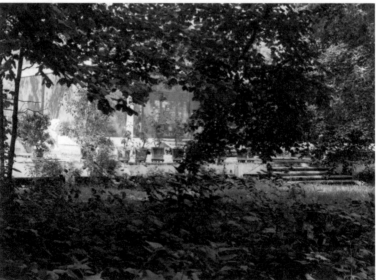

Farnsworth House, photos commissioned by Edith Farnsworth, 1960s

LUDWIG MIES VAN DER ROHE, FARNSWORTH HOUSE

wanted to transcend style and time. But something else resulted. Physical exposure in the glass pavilion is challenging enough, and the stress of being exposed is increased — whether consciously or unconsciously — by the presence of this spectral non-space under the building. Users of the Farnsworth House are surrounded by uncertainty. Paradoxically, Mies unwittingly created a psychologically charged building precisely because he believed so strongly that architecture spawned by technical and constructive logic was receptive to a new and higher unity with nature.

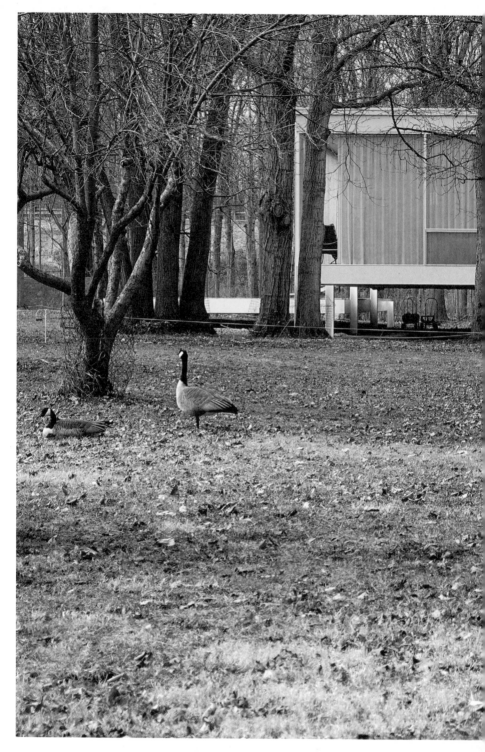

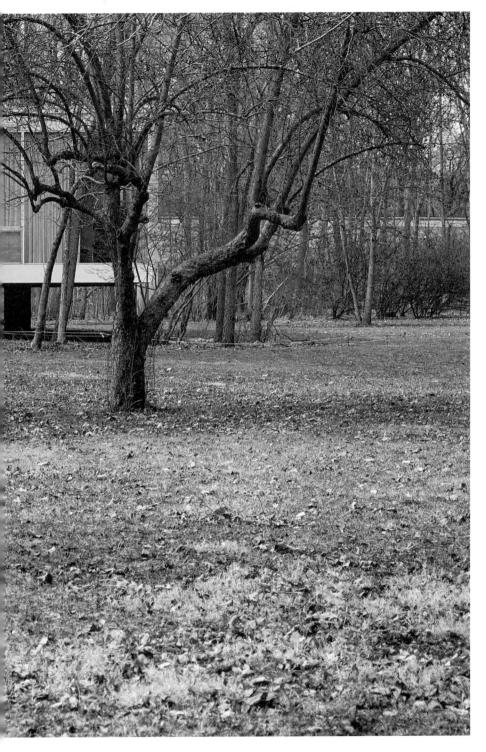

Dan Graham, *Alteration to a Suburban House*, 1978/1992
Wood, felt, Plexiglas, 28 × 109 × 122 cm
Walker Art Center, Minneapolis, Justin Smith Purchase Fund, 1993

DAN GRAHAM
ALTERATION TO A SUBURBAN HOUSE

Dan Graham (*1942) has always been intrigued by urban America, ever since he started out in the 1960s: the aesthetics of the International Style that dominates city centers as well as the repetitive, middle-class housing in endlessly sprawling suburbs. And he has always been interested in architecture, so much so that his knowledge of the field may well outstrip that of most architects. He often relates a work to its author, be it architect or artist, in unexpected, idiosyncratic ways, and in so doing, uncovers a wide range of psychological aspects and arguments.

Graham was obviously familiar with and fascinated by the work of Mies van der Rohe, as demonstrated by his glass pavilions: the detailing of his steel-framed glass structures corresponds 1:1 with the architecture of Mies's late glass towers and those of countless epigones. So he is, no doubt, a member of the epigonic guild: he takes an architectural product that already exists and appropriates it. But then he proceeds to create something entirely new that cannot be found in any architectural predecessors. There is a questioning, subversive, psychological something in Dan Graham's works that invariably brings viewers (people) into play. And it is only through that playful interaction that his constructions come to life.

The Farnsworth House does not want to be brought to life. The Farnsworth House is self-contained. It needs nothing and no one.

Dan Graham, the artist, looks at this architecture, studies it, and learns from it. He references architecture to make an artistic statement while architecture follows the straight and narrow

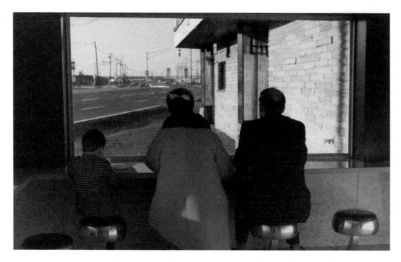

Dan Graham, *Homes for America*, 1966-1967
Untitled (Family in New Highway Restaurant), Jersey City, New Jersey, 1967
Slide projection, one of ca. 20 35-mm slides, carousel projector, installation variable

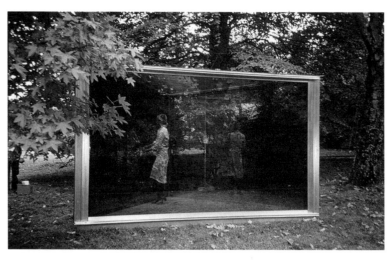

Dan Graham, *Double Exposure*, 1995/2003
Mirrored glass, glass, stainless steel, Cibachrome transparency, 248 × 410 × 355 cm
Fundação de Serralves, Porto

DAN GRAHAM, ALTERATION TO A SUBURBAN HOUSE

path of modernism without a single glance at artistic production. As seen in the Farnsworth House, Mies is firmly convinced that with his architecture he holds in his hands the key to a new, universal idiom.

Graham is best known for the glass pavilions he has created in many variations for as many different places both indoors and outdoors. In addition, he has produced an array of other conceptual projects, such as *Alteration to a Suburban House* (1978), which offers stimulating and fruitful insights with respect to the Farnsworth House.

The suburban house often features as the subject matter of Graham's work. The way in which the artist has modified his model of a suburban house in *Alteration to a Suburban House* pinpoints the interface between the suburban and the urban. He has replaced an entire façade and one inner wall by glass and a mirror. He has cut open and exposed the privacy of a suburban home, dissected it like a surgeon: the urban mirror world has penetrated the ordinarily hermetically sealed, suburban home, exposing its private sphere and presenting a psychological study of suburbia. Graham deplores the loss of urbanity, of life and exchange among people on the street, he exposes the guarded privacy of the home, which is visually screened off from the rest of the world.

In another project, *Video Projection Outside Home* (1978), he placed oversized television screens in the front yards of single-family homes that broadcast popular television programs into the street—ersatz communication among residents.

Dan Graham, *Video Projection Outside Home*, 1978
Architectural model, painted wood, plastic, 23 × 77 × 51 cm
Edition of 3, materials and dimensions variable

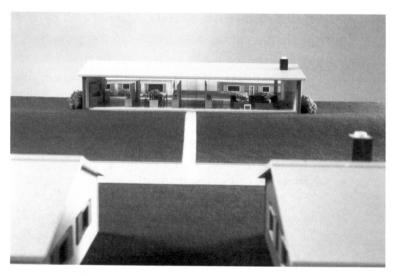

Dan Graham, *Alteration to a Suburban House*, 1978/1992

DAN GRAHAM, ALTERATION TO A SUBURBAN HOUSE

Exposing the interior, turning it inside out for everyone to see, makes viewers suffer an almost physical panic attack. *Alteration to a Suburban House* could therefore be seen as a kind of psychological diagram, as the Farnsworth House's artistic alter ego.

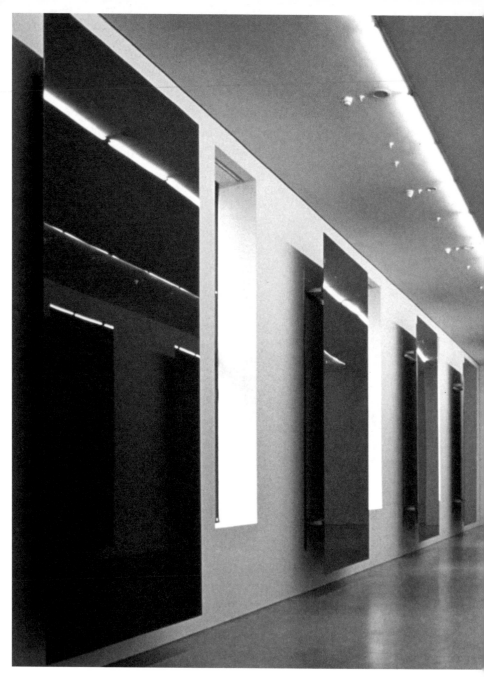

Gerhard Richter, *Acht Grau* (*Eight Gray*), 2002
Enameled glass in gray, steel, 500 × 270 × 50 cm each (W 878/1-8)
Installation view (Deutsche Guggenheim Berlin, October 11, 2002 – January 5, 2003)

GERHARD RICHTER
ACHT GRAU

By calling our study of selected artistic and architectural practices *Treacherous Transparencies*, we underscore the ambivalence of what it means to "see through"—both literally and figuratively.

Naturally, the idea that transparency can be deceptive does not yield a conclusive, much less a definitive interpretation of the works of art or pieces of architecture under discussion here. That includes Gerhard Richter (*1932). Nonetheless, although the title did not at first specifically target Richter's *Acht Grau* (*Eight Gray*), it proves to be particularly appropriate.

We have long been fascinated by Richter's work, especially because of its ambivalence, its ceaseless questioning and seeking in combination with a traditional approach. Richter is a painter. But at the beginning of his career, in the 1960s, he could not simply immerse himself in painting; he first had to find a new approach, like many of his peers. Painting was actually taboo.

It was no different for our generation of architects in the 1970s and early '80s. Doing architecture was also basically taboo: architectural modernism had failed to achieve its goal of establishing a universal idiom that would meet the various conditions and requirements of this world. Similarly, there were repeated attempts to do away with painting or to paint the "last picture," from Kazimir Malevich's *Black Square* to Ad Reinhardt's Black Paintings.

Richter's paintings sometimes seem abstract but then often morph into landscapes after all, as strikingly illustrated by his *128 Fotos von einem Bild* (*128 Photographs from a Painting*, 1978). Were he

Gerhard Richter, *Zeitungsfotos* (*Newspaper Photos*), 1962-1968
11 b/w paper cut-outs, 1 b/w photo, 51.7 × 66.7 cm. *Atlas*, Sheet 8
Städtische Galerie im Lenbachhaus und Kunstbau, Munich

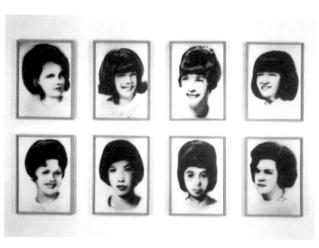

Gerhard Richter, *Acht Lernschwestern* (*Eight Trainee Nurses*), 1966
Oil on canvas, 95 × 70 cm each
Private collection

GERHARD RICHTER, ACHT GRAU

to paint realistic landscapes like the Old Masters, viewers would begin to wonder. In many places, his subject matter appears blurred and challenges perception. We are attracted to the work of art; it stimulates creative study. This involvement of the viewer is a vital constituent of an artistic approach that captured the imagination of other artists in those days as well, in particular the painter and theoretician Rémy Zaugg, with whom Pierre and I worked for many years.

Involving viewers also means making art that reaches into space. Richter's *Atlas* (from 1962) contains numerous sketches in perspective and designs for interiors, for monumental installations of murals, and for sculptural works with mirrors and glass. Richter contrived mechanical devices that would hold the mirrors and the glass so that they could tilt and turn on their own axis in various directions in order to take advantage of the refracted light and the reflections to create a variety of perspectives: of daylight, artificial light, people moving about in the room, colors in space, and the color of the glass, which, even if "neutral," is never completely transparent.

Most famous among his experiments with colored glass are the window designed for Cologne Cathedral (2007), and a glass window consisting of 625 colors in the stairwell of Haus Otte (1989). Both works—even the window in the profane stairwell—invariably evoke religious associations. The space is defined by the work of art and, conversely, the space restricts the work of art to a specific, namely religious content even if it consists only of randomly assembled, square patches of color without any narrative intent. The work of art has lost its openness, its ability to point in many

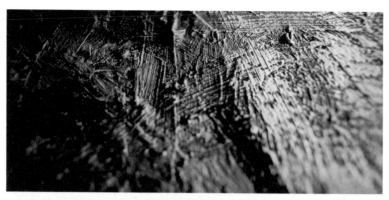

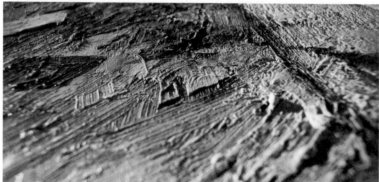

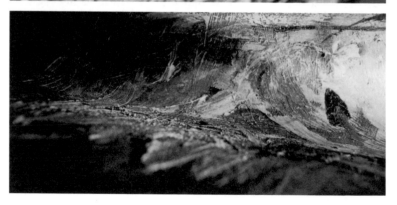

Gerhard Richter, *128 Fotos von einem Bild* (*128 Photographs from a Painting*), 1978
Photographs on card, 127 × 400 cm, three of 128 photographs

GERHARD RICHTER, ACHT GRAU

directions or in no direction at all, offering viewers the potential of choosing their own paths of perception.

4096 Farben (*4096 Colors*, 1974) takes an entirely different tack. At first sight, it is an ordinary color chart, a perfectly innocent painting on canvas like any other traditional painting. But the work is not that innocent. It raises fundamental questions about the identity of painting. Is it about depicting or is it the depicted? Is the picture representational or abstract? These are questions that do not have only one answer: they open up new perspectives, new forms of appreciation; they open up a space within the viewer.

The openness of his works is apparently of crucial concern to Richter.

Is that why there were only isolated experiments with colored glass and mirrors? In any case, he used commercial window glass to make his *4 Glasscheiben* (*4 Panes of Glass*, 1967).

Richter began experimenting with gray mirrors and glass early in his career. Why gray? Gray would become Richter's preferred "non-color"; he used it for abstract, monochromatic paintings, for realistic black-and-white works, and for mirrors. Gray has much less to do with content or narrative than, say, red or green or any other color. Gray is more banal, and therefore more open and emptier.

Richter's motivation for using the non-color gray probably shares that of other abstract artists who wanted to preclude any connotations of content in their paintings. Ad Reinhardt's Black Paintings,

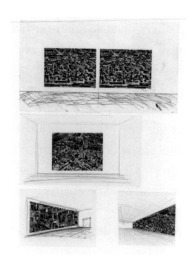

Gerhard Richter, *Städte* (*Cities*), 1968
12 b/w paper cut-outs (aerial views from books), 51.7 × 66.7 cm. *Atlas*, Sheet 112
Städtische Galerie im Lenbachhaus und Kunstbau, Munich

Gerhard Richter, *Atlas*, 1962-2013
Installation view (Städtische Galerie im Lenbachhaus und Kunstbau, Munich, October 23,
2013 – February 9, 2014)

GERHARD RICHTER, ACHT GRAU

on which he focused from the 1950s until his death in 1967, are perhaps the most radical attempt ever to eradicate all form, color, content, interpretation, and even any relationship with the viewer: Art-as-Art, unrelated to the world, art as a world of its own.

Although Reinhardt wrote many texts and conducted numerous conversations, it was obviously difficult to find words for his artistic approach: in the final analysis, only the painting itself can do that. It is painting that no longer invites viewers to be perceivers but, at most, allows them to be admirers.

Richter's gray pictures and mirrors point in a different direction. He had already experimented with gray mirrors in the 1970s. He presented *Eight Gray* for the first time in Berlin in 2002. It consists of eight vertical mirrors all of the same size and tinted in varying tones of gray. Every object and every movement in space is mirrored in them and becomes part of the work of art. What Richter has done here was something that Reinhardt wanted to avoid at all costs, which is why the black paintings had to be as matt and nonreflecting as possible. In contrast, Richter paradoxically achieved two things at once: on one hand, a maximum of abstraction in the form of gray mirrors and, on the other, a maximum of immediate, real-life figuration in the form of an immediate, mirrored world that exists in the here and now.

This ambivalence between abstraction and representation makes *Eight Gray* an open-ended work of art that trips up any attempt to pin down its content or iconography: it is about painting but is also about photography because of the ephemeral, accidental, latent visuality of the work. In Richter's own words,

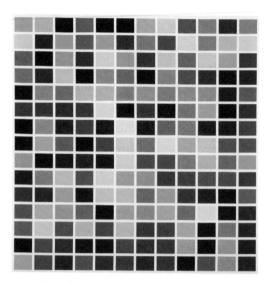

Gerhard Richter, *180 Farben* (*180 Colors*), 1971
Oil on canvas, 180 × 100 cm. Philadelphia Museum of Art, Gift (by exchange)
of Mrs. Herbert Cameron Morris, 1998

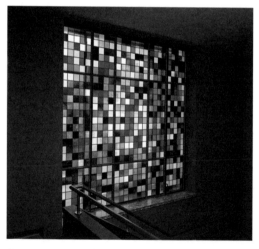

Gerhard Richter, *Glasfenster, 625 Farben* (*Glass Window, 625 Colors*), 1989
273 × 268 cm, Haus Otte, Berlin-Zehlendorf

GERHARD RICHTER, ACHT GRAU

Illusion—or better appearance, light (Schein = light, appearance)—is my life subject. ... Everything there is, appears, shines and is visible for us because we perceive the light that it reflects, nothing else is visible.

(Tate 1991, p. 123)

Since the visible, mechanical brackets are part of the work, *Eight Gray* is also a sculpture or a relief. However, it can also be read in terms of traditional painting, as a group of eight panels, a multipart whole, like the panels of medieval altars. The gray mirrors also recall the repetitive features of modern architecture, for example, a row of windows. There is something both ordinary and sublime about the gray tinting. Mirrors are omnipresent in cities and yet in no way comparable to these. Richter's are not commercial mirrors in which viewers see their own clear-cut mirror image.

Finally, *Eight Gray* reaches into concrete space. But into what kind of space? Or, to put it differently: What would the ideal space be like?

So far there are two versions of this work: one in the collection of the 21st Century Museum of Contemporary Art, Kanazawa (W 874/1-8, 2001), and the other in the collection of the Solomon R. Guggenheim Museum, New York (W 878/1-8, 2002). None of the installations to date has succeeded in creating the space required that would transform an arrangement of eight gray, reflecting panels into a real place.

A place is created only when its space becomes an architectural space, which means defining it architecturally, with proportions,

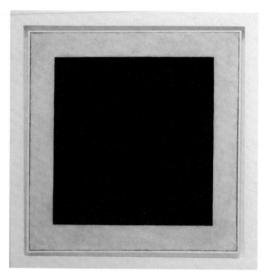

Kazimir Malevich, *Black Square*, 1915
Oil on canvas, 80 × 80 cm, State Tretyakov Gallery, Moscow

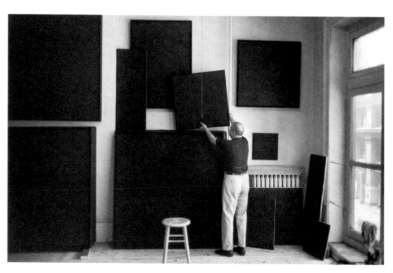

Ad Reinhardt (1913-1967) hangs his paintings to dry in a studio,
New York, 1966

GERHARD RICHTER, ACHT GRAU

materials, windows and doors, daylight and artificial light, and so on. That means a space with an architectural identity that can be given a name, such as, exhibition space, office, garage, chapel, and the like. An architecturally defined space of that kind is no problem at all for many works of art.

Dan Graham's mirror and glass structures could, for instance, be installed in an office or a garage; they do not have to be in a gallery or a museum. They may be models that can be presented anywhere, like the above discussed *Alteration to a Suburban House*, or they may be site-specific, like the pavilions that he has created for a given location. Their aesthetic relies on the concrete architectural repertoire of the International Style. They were conceived as objects that reference specific spatial and cultural aspects; their intellectual origin is the urban culture of modernism in the United States, to which they explicitly refer. That makes them easier to transplant although they, too, are geared towards interaction with the viewer, as in Richter's art.

Richter's *Eight Gray* is more problematic. Spatial autonomy of that kind does not work in this case. His mirrors cannot be unequivocally defined. Their identity keeps changing the moment there is movement in the surrounding space and the viewer looks at them. Richter's mirrors, twisted or tilted vertically and/or horizontally, take complete possession of the entire space, including all the corners, including the entrance and beyond. They require a space that does not limit the viewer's perception, that does not chart a predetermined trail, that does not instantly reveal function and purpose, as if the space were a chapel or an office. It must be a concrete, physical space but not one with a clear-cut, predeter-

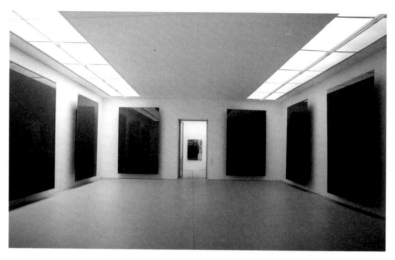

Gerhard Richter, *Acht Grau* (*Eight Gray*), 2001
Gray enameled glass and steel, 320 × 200 × 30 cm each (W 874/1-8)
Installation view (studio of Gerhard Richter, Cologne, 2001)

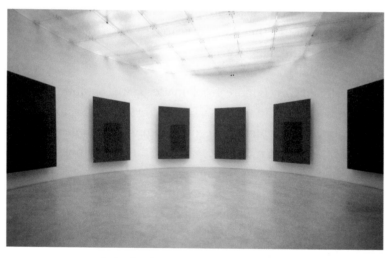

Gerhard Richter, *Acht Grau* (*Eight Gray*), 2001
Installation view (21st Century Museum of Contemporary Art, Kanazawa, Japan,
March 9 – October 26, 2005)

GERHARD RICHTER, ACHT GRAU

mined function, which is especially important here because the space will, in turn, leave its mark on the perception of *Eight Gray*.

For the presentation of *Eight Gray* at the Deutsche Guggenheim, Richter had the opaque windows replaced with clear panes of glass because he wanted the daylight and what is happening outside to be part of the work. He did not simply accept but actually embraced vitality and sensuality as integral features of *Eight Gray* (Buchloh 2002, p. 28).

Both artists, Richter and Graham, use transparency and mirroring as a means of activating the critical perception and creative energy of viewers in relating to their work. Viewers or, in architectural spaces, "users" are thus indispensable agents, even though they are only accidental, ceaselessly changing features of the work. Particularly in Richter's *Eight Gray*, one cannot escape the way in which these gray, reflecting pieces of glass reach out and take possession of an architectural space, in full awareness of the psychological impact on viewers, on the perceiving users.

Richter's work can be seen as a kind of experimental machine to test architectural models or better yet, to test model-like architecture. A model-like ideal space for *Eight Gray* requires paradoxical architecture that links openness with determination. Only in that way can the potential of these gray mirrors unfold and, even more importantly, only in that way can viewers benefit from the work's openness to give their own perception free rein.

The opposite applies to the conception of the Farnsworth House: it was not conceived as a model that would join the life of the

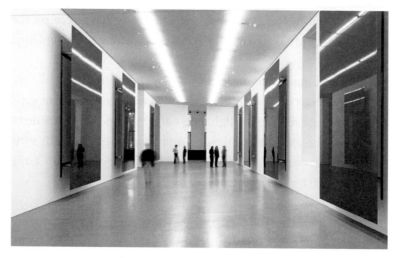

Gerhard Richter, *Acht Grau* (*Eight Gray*), 2002
Enameled glass in gray, steel, 500 × 270 × 50 cm each (W 878/1-8)
Installation view (Deutsche Guggenheim, Berlin, October 11, 2002 – January 5, 2003)

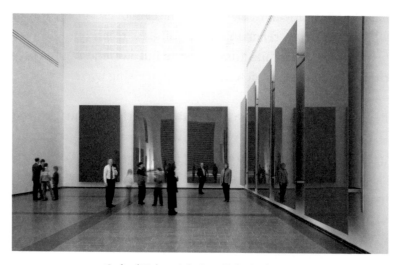

Gerhard Richter, *Acht Grau* (*Eight Gray*), 2002
Installation view (Kunstsammlung Nordrhein-Westfalen, Düsseldorf,
February 12 – May 16, 2005)

GERHARD RICHTER, ACHT GRAU

perceiving user from the inside out, nor as a model that would have permitted the natural forces of the outside world to affect the interior so as to ensure enduring quality in the daily life of the perceiving user.

Farnsworth House is not a model; it is a statement, an assertion. Farnsworth House is a built will to form: a minimal form with maximum transparency. Glass is required only to separate the outside from the inside. Mies no doubt appreciated the decorative light reflections on the panes of glass, but he forfeited not only the potential of glass as a material but also the perceiving user, by completely ignoring her vibrant interaction with the architectural space.

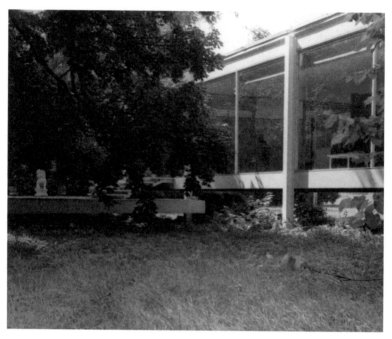

Farnsworth House, photo commissioned by Edith Farnsworth, 1960s

EPILOGUE

The two continents of the Americas bear a history rooted in discovery, invention, and innovation: a culture initially formed by adapting or drawing upon European, African, and Asian influences. The American continents have long ago come of age and this award seeks to build—through a global dissemination of its results—a platform that will engage students, academics, and professionals alike. The MCHAP hopes to inspire practitioners to excellence and nurture an impassioned exchange of ideas. Only in this way can we advance our species and its many cultures; only in this way can we step into an unpredictable future with both confidence and optimism.

The College of Architecture at Illinois Institute of Technology (IIT) established the Mies Crown Hall Americas Prize (MCHAP) to recognize the most distinguished architectural works built on the North and South American continents. It is a great privilege to launch the MCHAP publication series with a work by the winners of the inaugural MCHAP award Jacques Herzog and Pierre de Meuron for their project 1111 Lincoln Road in Miami Beach.

Jacques's affiliation with art and Pierre's passion for engineering were the starting point for an architectural practice that would not have been so influential were it not for the friendship they have shared since their youth. They are generous, ethically aware, and real people, with an outspoken social agenda and have established from the first a series of fruitful collaborations with artists. They live, work, and conduct research out of their hometown Basel, and the office they established in 1978 is still in the same part of Basel's historic city center, although the house they started their office in has become part of a small Herzog & de Meuron neighborhood. It is because of their incredible impact on the global architectural scene that they were able to start, beyond the confines of Zurich, their ETH Studio Basel to do research on the city.

In October 2014 we held a conversation at Farnsworth with our jury chair Kenneth Frampton and the impact of these explorations of the Farnsworth House was arguably the stimulus for Jacques and Pierre to choose the Farnsworth House as their research topic.

The book *Treacherous Transparencies* is a critical statement written and edited by Jacques Herzog around the argument of "the sphere of pure art" as it relates to Mies's Farnsworth House, with amazing photos by Pierre de Meuron.

Wiel Arets

COLOPHON

This publication is an initiative of the Illinois Institute of Technology's College of Architecture and its affiliated Mies Crown Hall Americas Prize (MCHAP). This award was launched by Wiel Arets, the Illinois Institute of Technology College of Architecture Dean and Rowe Family College of Architecture Dean Endowed Chair, on 13 March 2013 as one of his first initiatives as Dean. The inaugural MCHAP jury was chaired by Kenneth Frampton and included Jorge Francisco Liernur, Dominique Perrault, Sarah Whiting, and Wiel Arets. The content of this publication was first presented as a lecture entitled "Treacherous Transparencies: Thoughts and Observations Triggered by a Visit to the Farnsworth House" by Jacques Herzog at S. R. Crown Hall on 7 March 2016. This book is the first of an MCHAP series that will collect and reflect on the prize's founding and development. The President of MCHAP would like to thank all those who made this program and publication possible: Illinois Institute of Technology, College of Architecture, the The City of Chicago, and the firms and individuals that generously support the initiative.

AUTHORS

Jacques Herzog (Basel, 1950) studied architecture at the Swiss Federal Institute of Technology Zurich (ETH Zurich) from 1970 to 1975 with Aldo Rossi and Dolf Schnebli. He was a visiting tutor at Cornell University in 1983, has been a visiting professor at the Harvard Graduate School of Design in 1989 and since 1994, has been a professor at ETH Zurich since 1999, and co-founded the ETH Studio Basel–Contemporary City Institute in 2002.

Pierre de Meuron (Basel, 1950) studied architecture at the Swiss Federal Institute of Technology Zurich (ETH Zurich) from 1970 to 1975 with Aldo Rossi and Dolf Schnebli. He has been a visiting professor at the Harvard Graduate School of Design in 1989 and since 1994, has been a professor at ETH Zurich since 1999, and co-founded the ETH Studio Basel–Contemporary City Institute in 2002.

Jacques Herzog and Pierre de Meuron established Herzog & de Meuron in Basel in 1978. The architectural partnership has grown over the years to an international team of Partners, Associates and collaborators, with additional offices in Hamburg, London, Madrid, New York, and Hong Kong. Working across Europe, the Americas and Asia, Herzog & de Meuron has realized a wide range of projects from small-scale homes to large-scale urban design. The practice is noted for its work on cultural projects for the public and its collaborations with artists. It has been awarded the Pritzker Architecture Prize (2001), the RIBA Royal Gold Medal (2007), the Praemium Imperiale (2007), and the Mies Crown Hall Americas Prize (2014).

BIBLIOGRAPHY

Buchloh, Benjamin H. D., "Gerhard Richter's Eight Gray: Between Vorschein and Glanz," in: Buchloh, Benjamin H. D. and Cross, Susan (eds.), *Eight Gray 2002*, New York: Guggenheim Museum Publications, 2002, pp. 13-29.

De Magistris, Alessandro and Korob'ina, Irina (eds.), *Ivan Leonidov 1902-1959*, Milan: Electa, 2009.

Farnsworth, Edith, *Artifact*, unpublished poem, 1960. Courtesy of The Newberry Library, Chicago.

Farnsworth, Edith and Barry, Joseph A., "Report on the Battle between Good and Bad Modern Houses," in: *House Beautiful*, no. 5, 1953.

Frehner, Matthias and Spanke, David (eds.), *Stein aus Licht, Kristallvisionen in der Kunst* (exhibition catalogue), Bielefeld: Kunstmuseum Bern/Kerber Verlag, 2015.

Johnson, Philip, *Mies van der Rohe*, New York: The Museum of Modern Art, 3rd ed., 1978.

Neumeyer, Fritz, "Mies as Self-Educator," in: Rolf Achilles (ed.), *Mies van der Rohe: Architect as Educator* (exhibition catalogue), Chicago: University of Chicago Press/Illinois Institute of Technology, 1986, pp. 27-36. See also: https://archive.org/stream/miesvanderrohear00edit/miesvanderrohear00edit_djvu.txt

—, *Mies van der Rohe. Das kunstlose Wort. Gedanken zur Baukunst*, Berlin: Siedler, 1986 (English version: *The Artless Word, Mies van der Rohe on the Building Art*, Cambridge, MA: The MIT Press, 1991).

Norberg-Schulz, Christian, "A Talk with Mies van der Rohe," in: *Baukunst und Werkform*, no. 11, 1958. Also in Neumeyer, Fritz, 1991.

Palumbo, Peter, "Farnsworth Impressions," in: Blaser, Werner, *Mies van der Rohe. Farnsworth House. Weekend House*, Basel: Birkhäuser, 1999, pp. 14–17.

Rainbird, Sean (ed.), *Gerhard Richter* (exhibition catalogue), London: Tate Gallery, 1991.

Taut, Bruno, *Die Stadtkrone*, Jena: Eugen Diederichs, 1919.

Vandenberg, Maritz, *Farnsworth House*, London: Phaidon, 2003.

IMAGE CREDITS

Front cover, front endpaper, 54 (bottom), 56, 60, 86: Edith Farnsworth Papers, The Newberry Library, Chicago

6, 8, 32-33, 34, 38, 44, 46, 48, 62-63: Pierre de Meuron

10: Galleria Nazionale d'Arte Antica Palazzo Barberini, Rome

16, 18 (top): Bruno Taut Archive, Akademie der Künste, Berlin

18 (center): Ben Buschfeld

18 (bottom): Bildarchiv Foto Marburg

20: Fondo Russo dell'Avanguardia, Moscow

22 (top), 76 (bottom), 80 (top): Alamy Stock Photo

24: Private Archive Selim Omarovic

26: Tate, London 2016, Richard Hamilton / Succession Marcel Duchamp / ADAGP, Paris / DACS, London

28 (top): Philadelphia Museum of Art, Authorship Julian Wasser

28 (bottom): Münchner Stadtmuseum

30: Yale Collection of American Literature, Beinecke Rare Book and Manuscript Library, Yale University

36 (top): Werner Blaser

36 (bottom): Chicago History Museum, Courtesy of Krueck and Sexton Architects

40: Roland Kernen and Theo Odermatt

50: Staatliche Museen zu Berlin

52: National Trust for Historic Preservation

54 (top): The Mies van der Rohe Archive, Museum of Modern Art, New York / Scala, Florence

58 (bottom): 1966 Metro-Goldwyn-Mayer Inc. and 2004 Turner Entertainment

64: Walker Art Center

66: Dan Graham

68: Dan Graham, Photos by Angela Cumberbirch

70: Gerhard Richter / Solomon R. Guggenheim Foundation, New York, Photo by Mathias Schormann

72 (top), 76 (top): Städtische Galerie im Lenbachhaus and Kunstbau München

72 (bottom), 78 (bottom): Gerhard Richter

74: Kunstmuseen Krefeld

78 (top): Philadelphia Museum of Art

80 (bottom): Getty Images

82 (top): Gerhard Richter

82 (bottom): Gerhard Richter / Courtesy of 21st Century Museum of Contemporary Art, Kanazawa, Photo by Keizo Kioku

84 (top): Gerhard Richter / Deutsche Guggenheim Berlin

84 (bottom), back endpaper, back cover: Werner Hannappel

The Authors and Actar Publishers are especially grateful to the image providers. Every reasonable attempt has been made to identify owners of copyright. Should unintentional mistakes or omissions have occurred, we sincerely apologize. Such mistakes will be corrected upon notification in the next edition of this publication.

IMPRINT

Published by
IITAC Press
College of Architecture
3360 South State Street
Chicago, IL 60616-3793, USA
Phone +1 312 567 3230
www.arch.iit.edu

Actar Publishers
355 Lexington Avenue, 8th Floor
New York, NY 10017, USA
Phone +1 212 966 2207
salesnewyork@actar-d.com
eurosales@actar-d.com
www.actar.com

Concept and text: Jacques Herzog
Photographs of the Farnsworth House:
Pierre de Meuron
Design and research: Jacques Herzog,
Donald Mak, Stefanie Manthey
Editor: Catherine Hürzeler

Translation: Catherine Schelbert

Texts supervision: Moisés Puente
Images supervision: Ricardo Devesa
Design supervision: Edwin van Gelder
(Mainstudio) and Ramon Prat (Actar)

Printing: Unicum, Tilburg,
The Netherlands

Illinois Institute of Technology
President of MCHAP and Dean of the
College of Architecture: Wiel Arets
Director of MCHAP: Dirk S. Denison
Director of Publishing: Daniel O'Connell
MCHAP Coordinator: Sasha Zanko
IITAC Press Editor: Lluís Ortega
Director of Research: Vedran Mimica

Printed in The Netherlands
ISBN 978-1-945150-11-1
Library of Congress Control Number:
2016942636

A CIP catalogue record for this book
is available from Library of Congress,
Washington, D.C., USA

 College of Architecture
ILLINOIS INSTITUTE OF TECHNOLOGY

IITAC

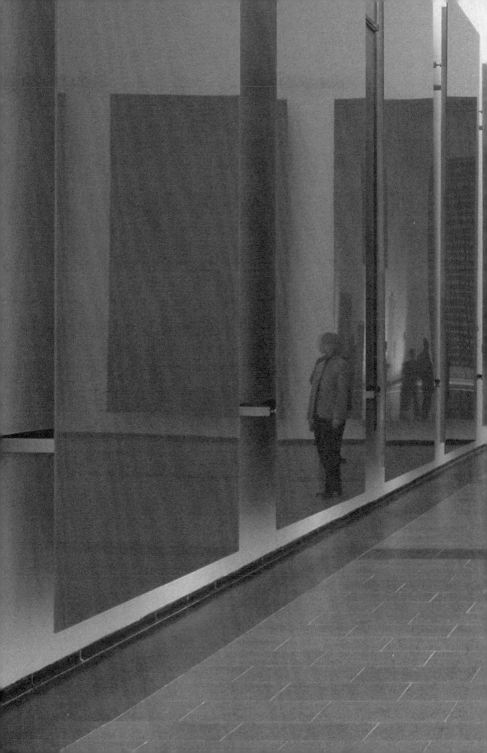